FANTASTIC BEASTS AND WHERE TO FIND THEM characters, names and related indicia are $\mathbb C$ & TM Warner Bros. Entertainment Inc. WB SHIELD: TM & © WBEI. J.K. ROWLING'S WIZARDING WORLD™ J.K. Rowling and Warner Bros. Entertainment Inc. Publishing Rights © JKR. (s16)

INSIGHTS

INSIGHT SEDITIONS

San Rafael, California www.insighteditions.com

10987654321